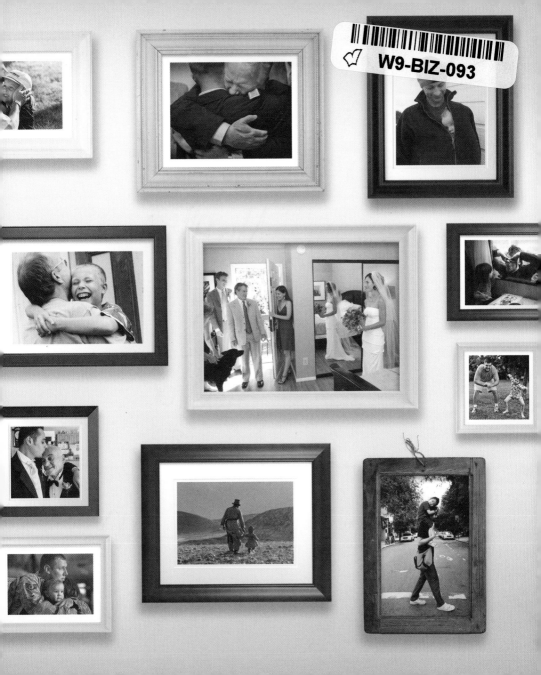

We love you!!
So very much!!

Love Always,

Melissa
Taylor
&

Ian

Edited by
Geoff Blackwell

DEAR
DAD

PQ Blackwell

in association with

CHRONICLE BOOKS
SAN FRANCISCO

A father
is someone
you
look up to
no matter
how tall
you
grow.

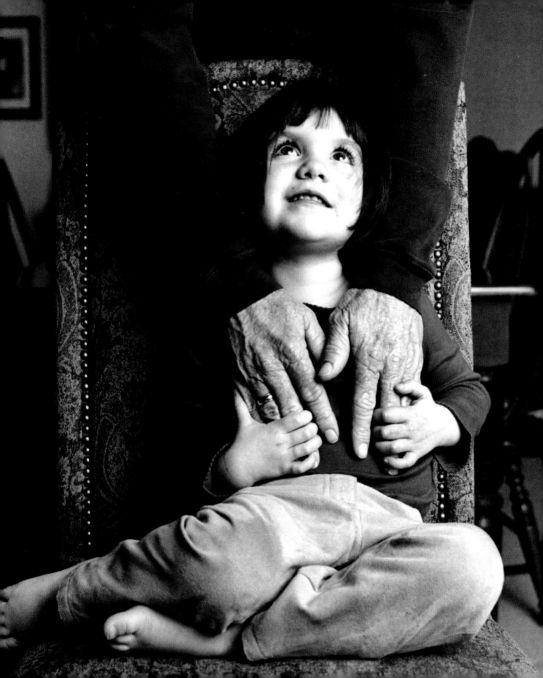

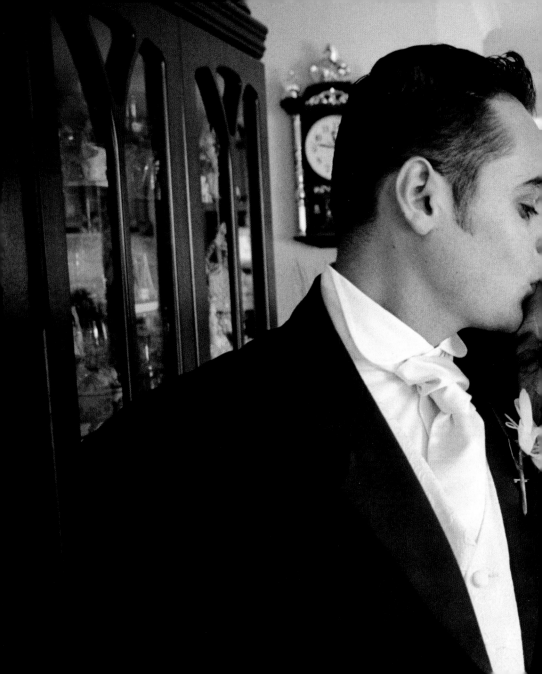

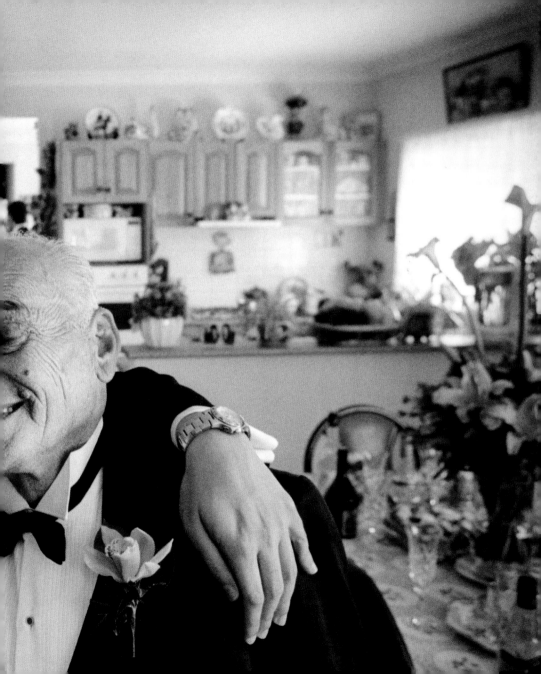

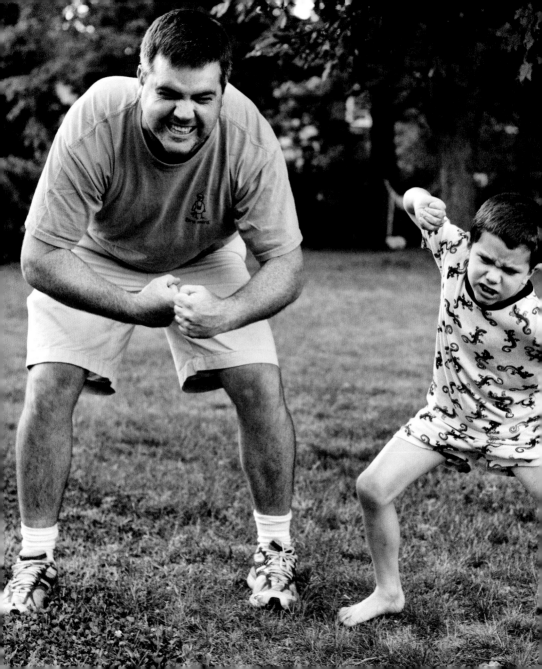

Dads

don't need to be
tall and broad-
shouldered and clever.

Love

makes them so.

Pam Brown

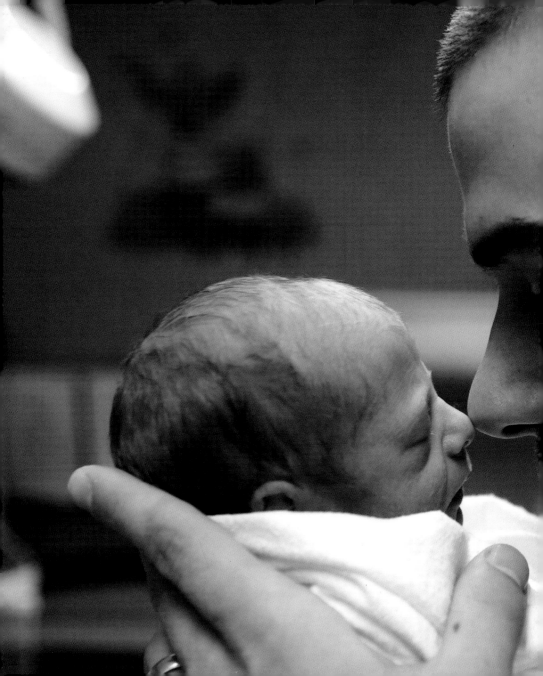

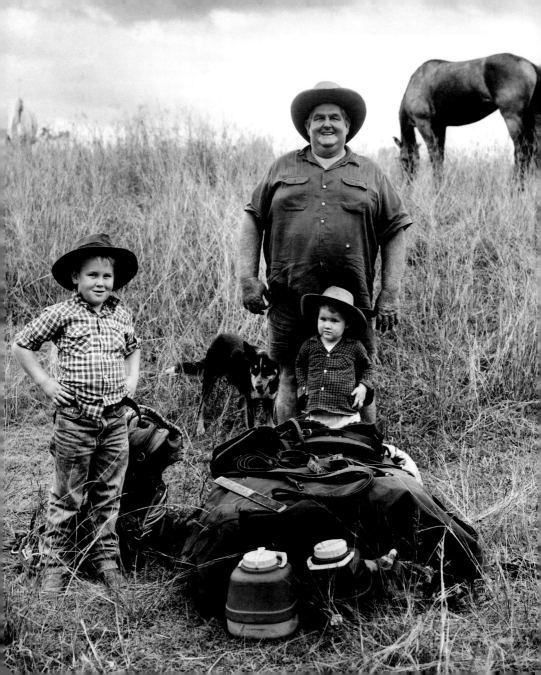

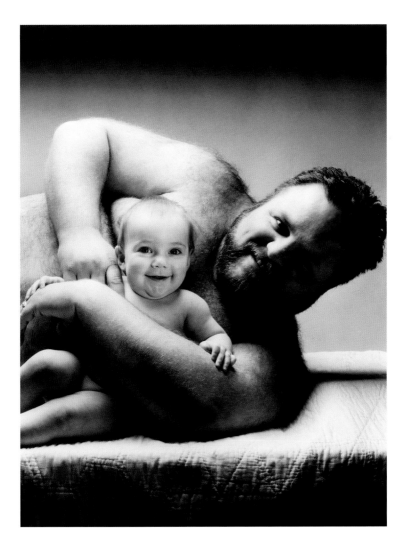

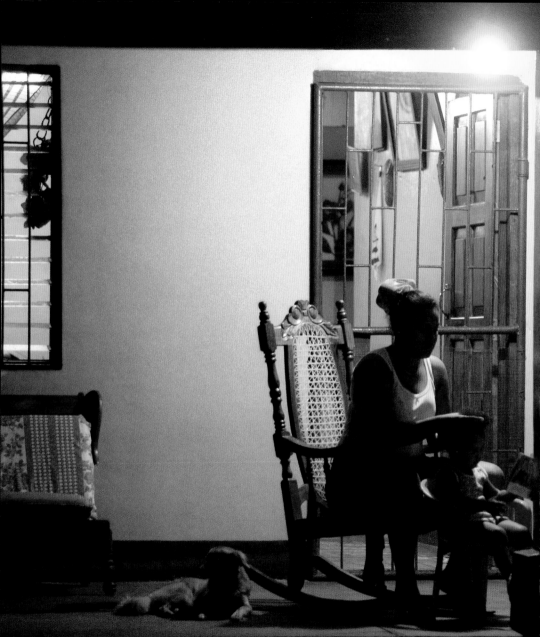

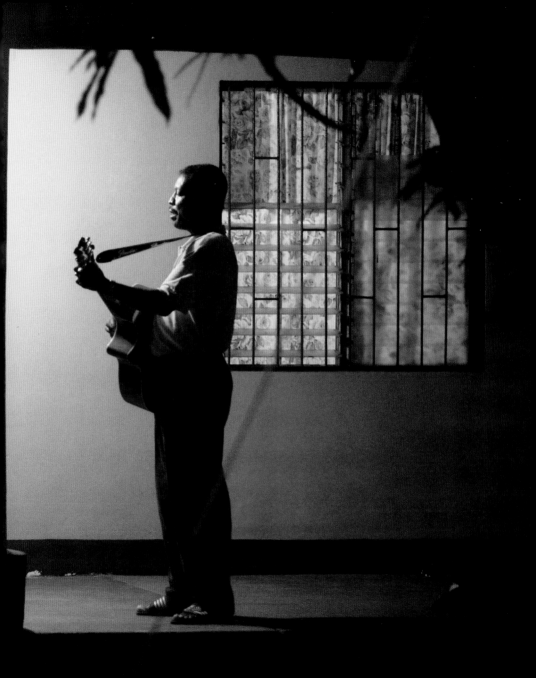

It is a curious **thought,** but it is only when you see people looking *ridiculous* that you realize just how much you love them.

Agatha Christie

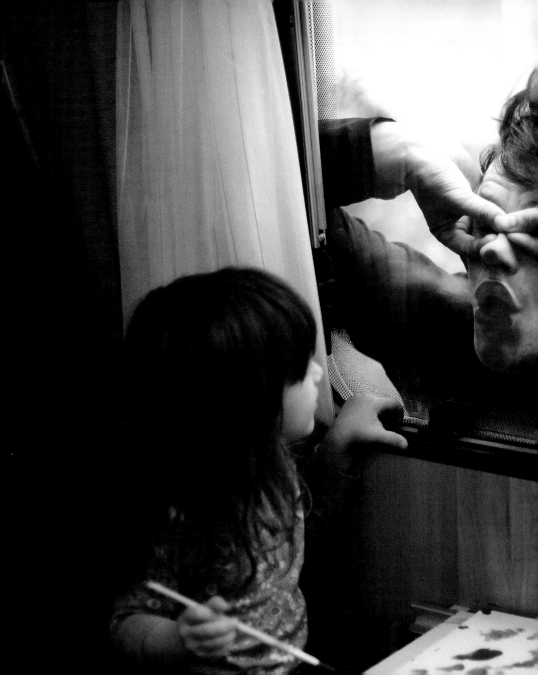

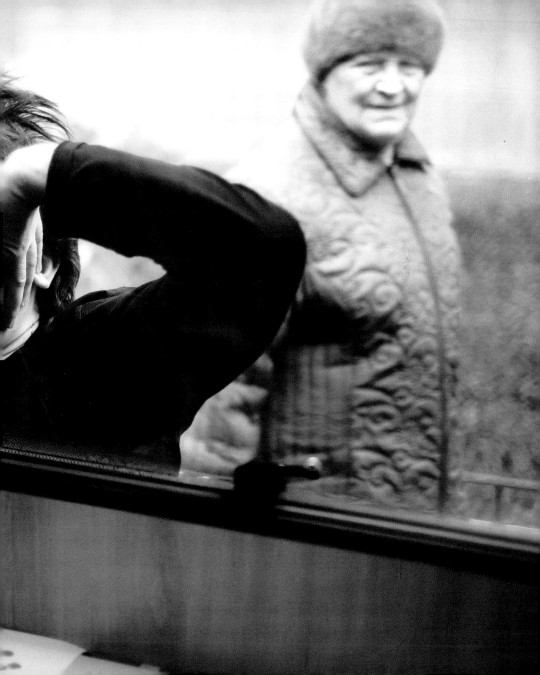

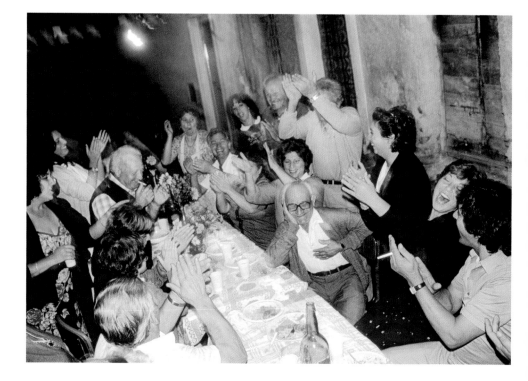

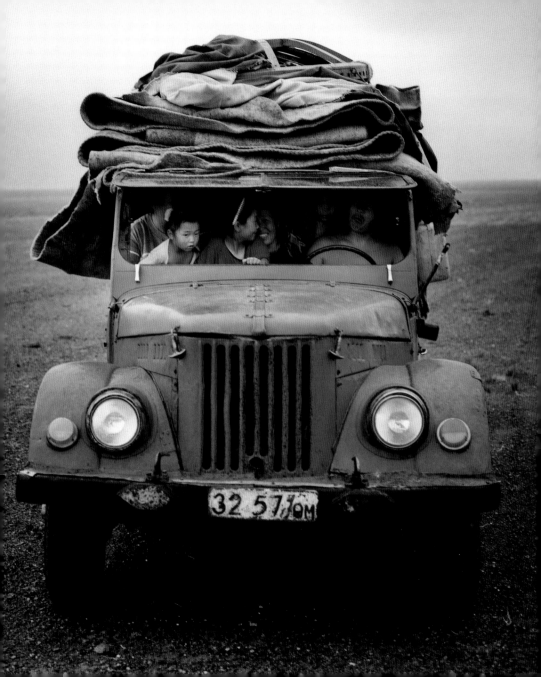

Up on his
shoulders
is where
I love
to be.

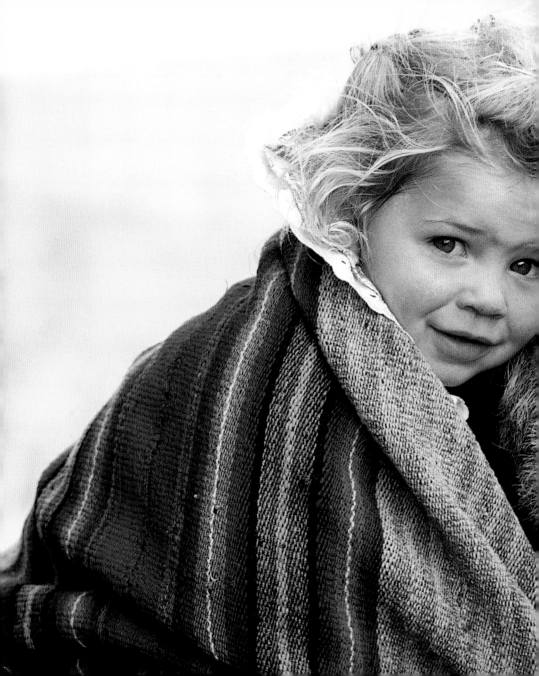

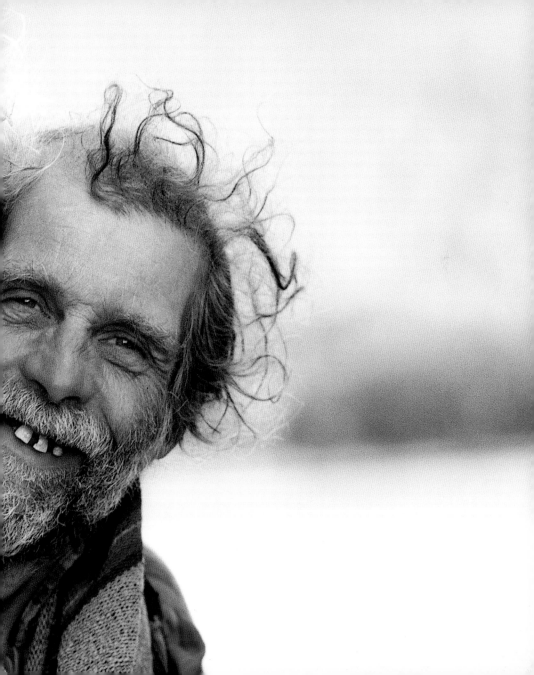

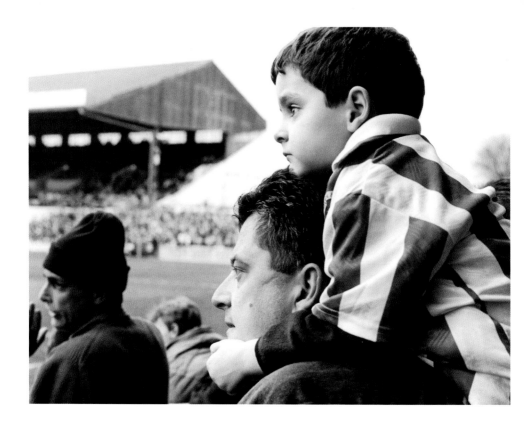

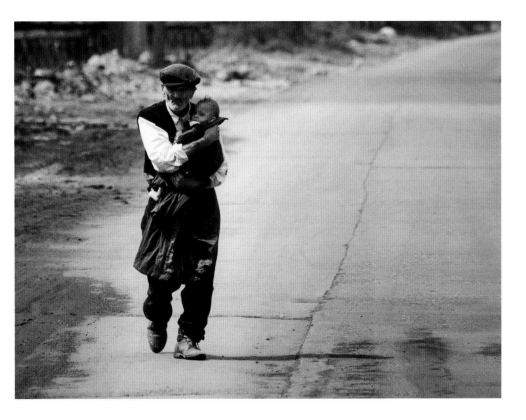

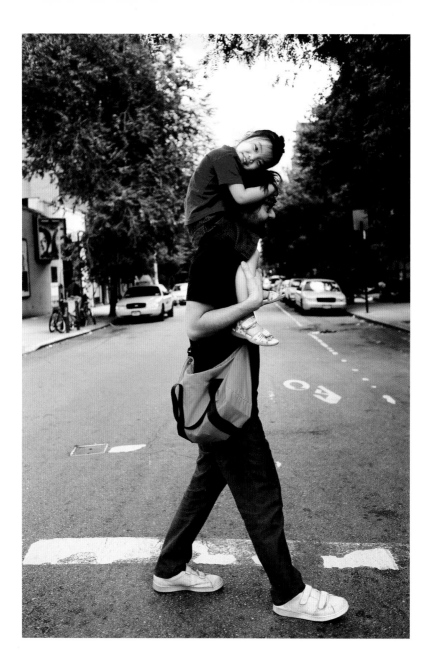

If there's one
man a girl can
depend
upon, it's her
daddy.

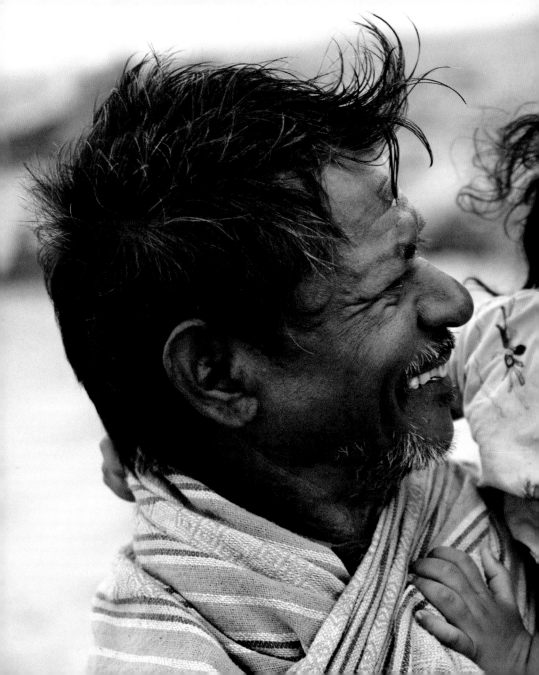

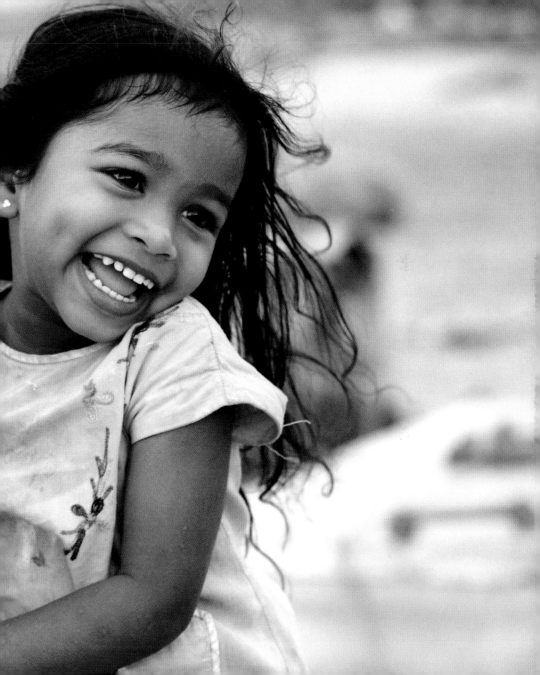

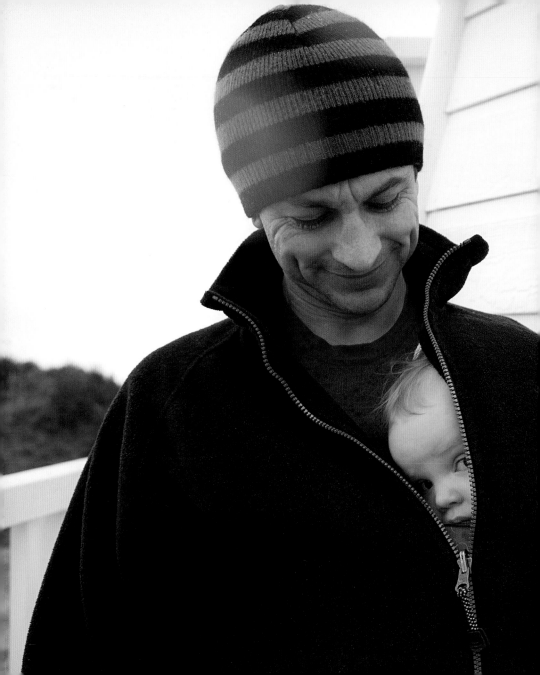

Fathers
are the original
superheroes.
No one
else can save
the day like
a dad can.

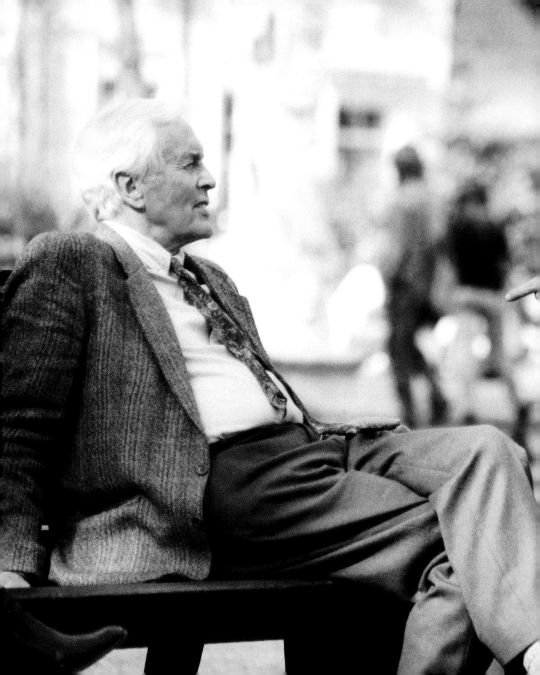

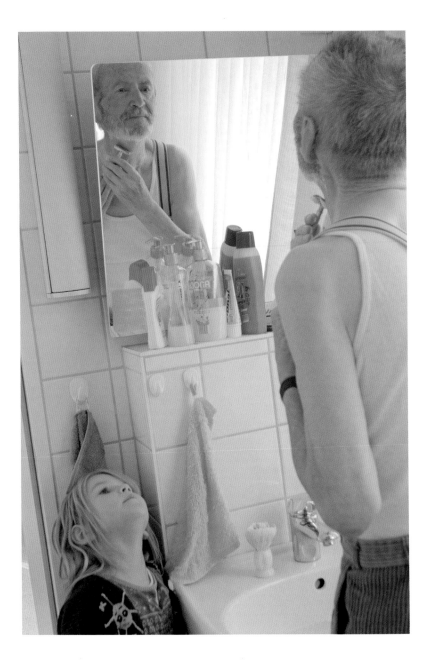

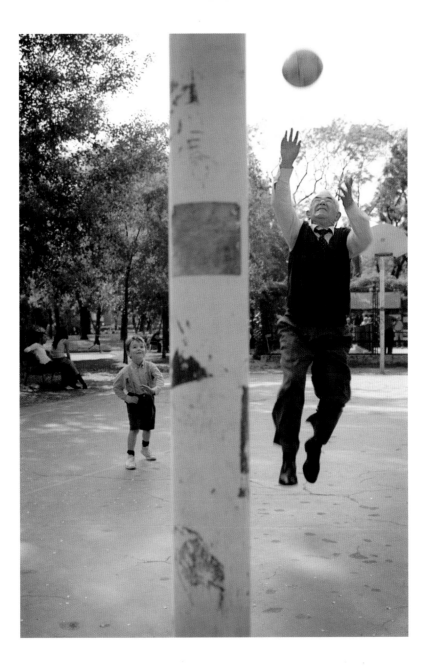

To her the
name of *father*
was another name
for love.

Fanny Fern

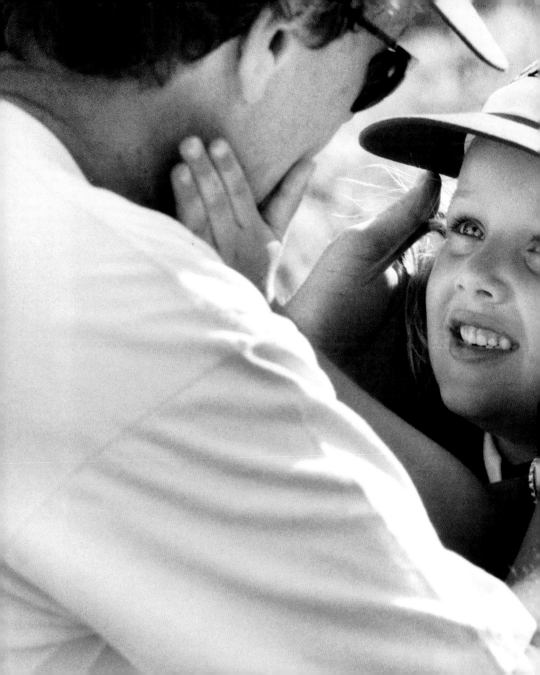

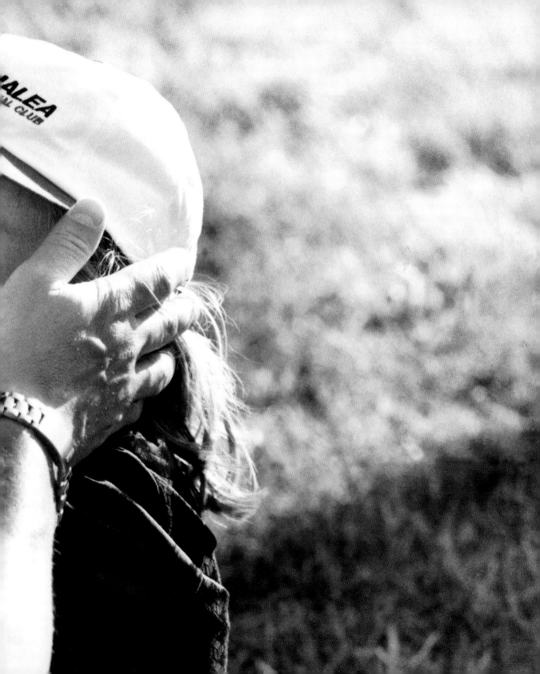

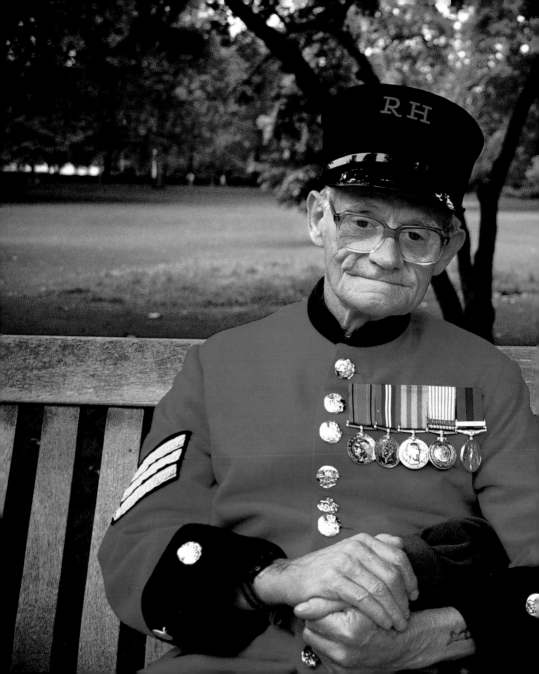

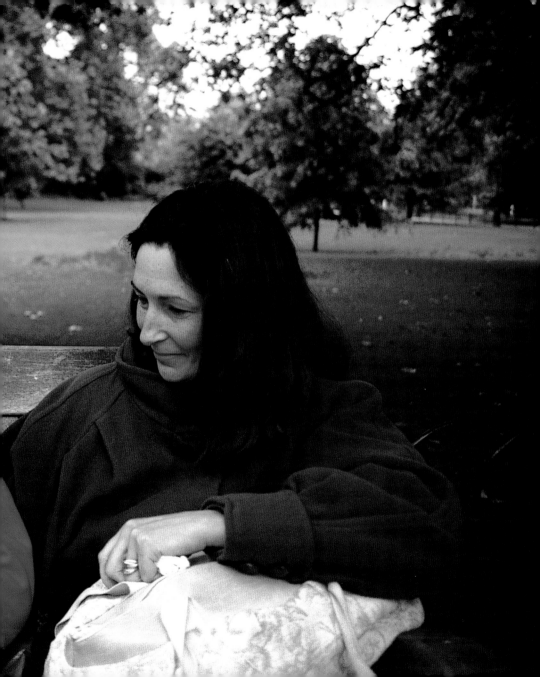

I love my dad.
And you know what?
HE LOVES ME!
(And he always will.)

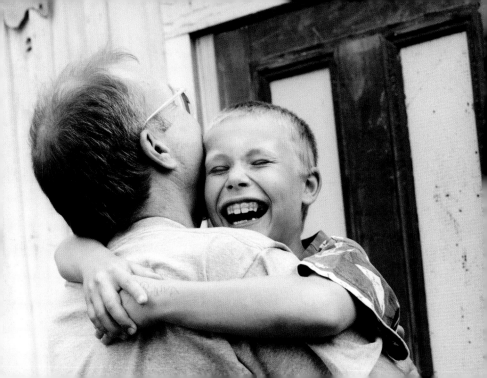

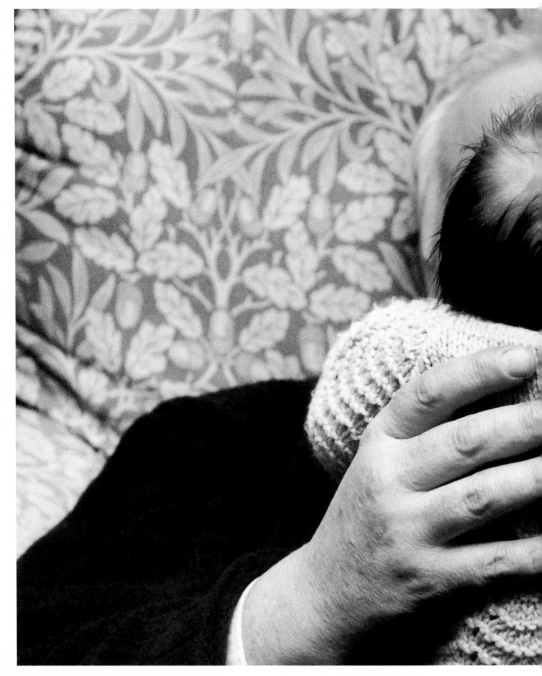

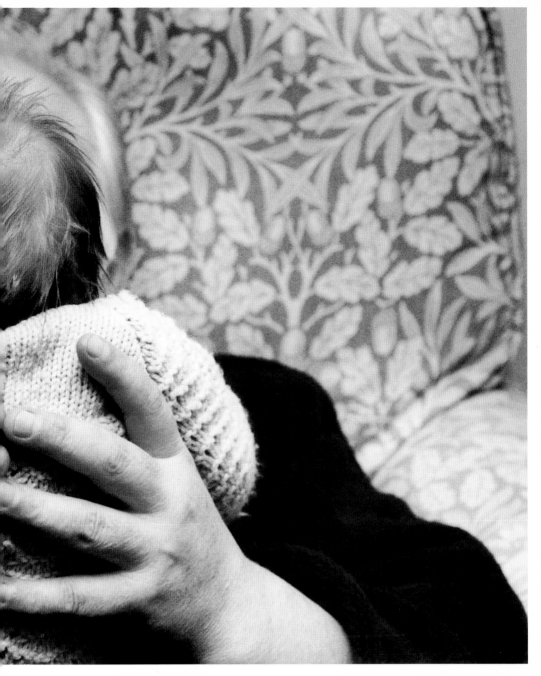

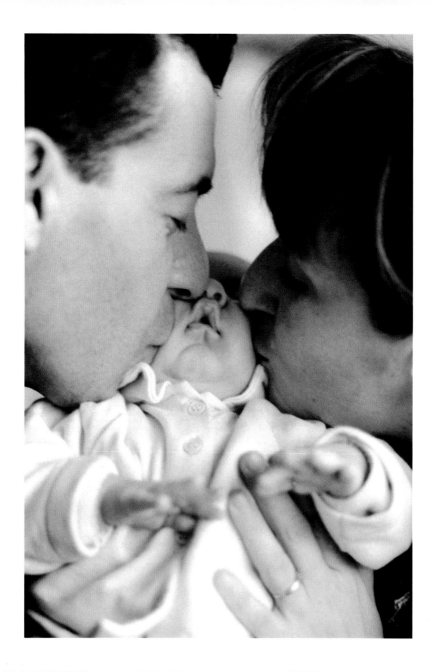

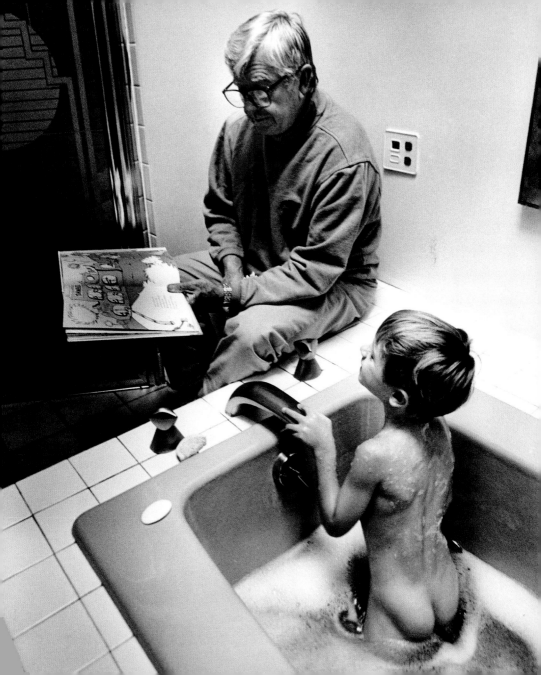

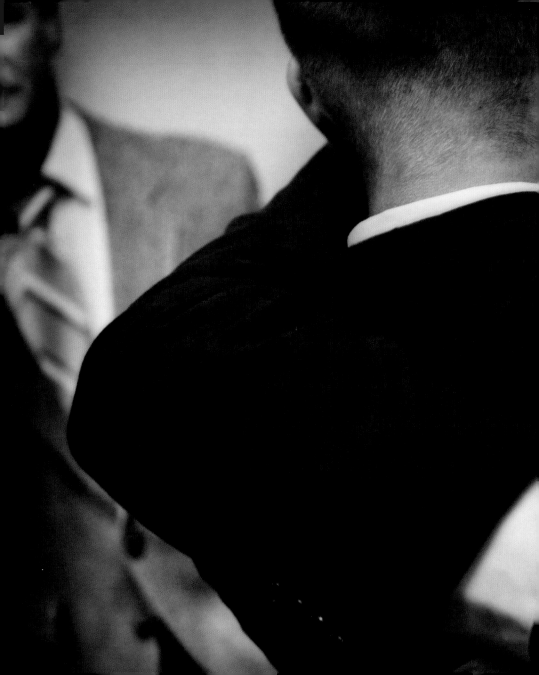

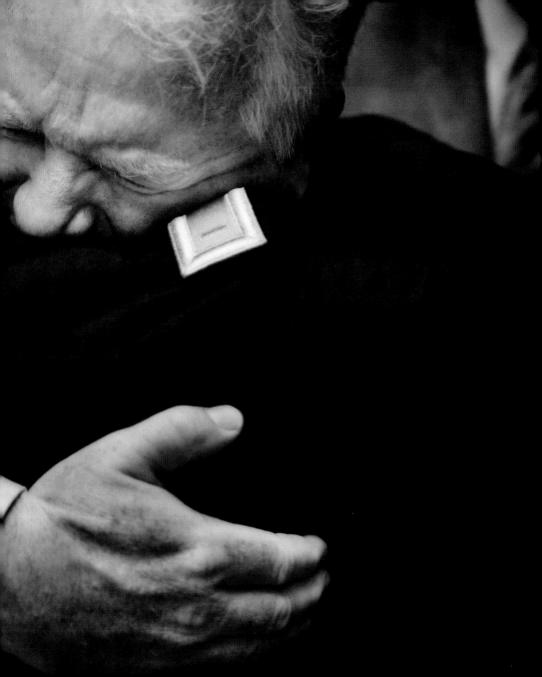

Dads are

stone skimmers, mud wallowers, water
wallopers, ceiling swoopers, shoulder
gallopers, upsy-downsy, over-and-
through, round-and-about whooshers.
Dads are smugglers and secret sharers.

Helen Thomson

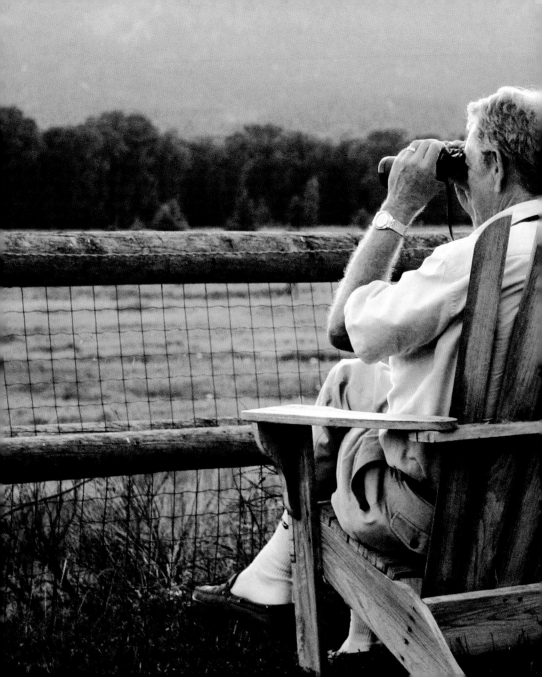

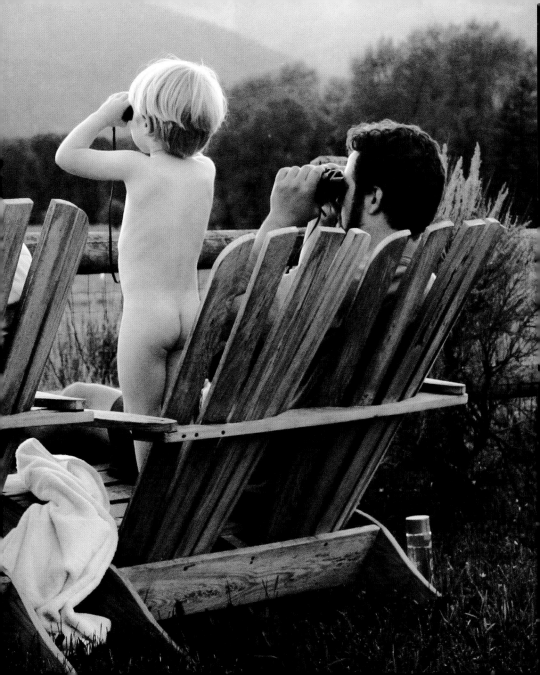

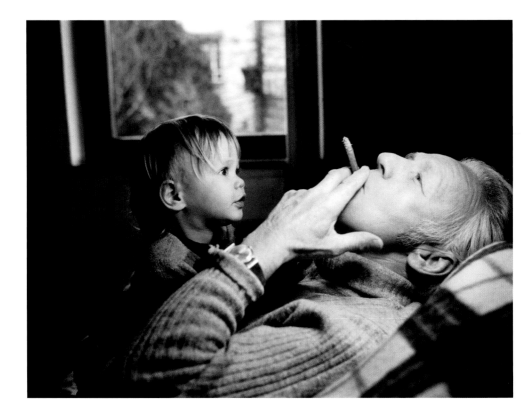

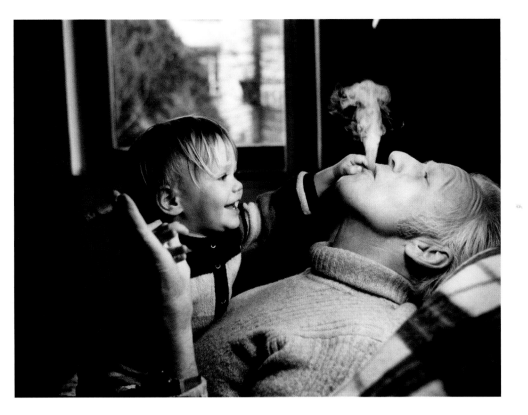

It is *admirable* for a man
to take his son fishing,
but there is a
special place in
heaven for the

father

who takes his
daughter
shopping.

John Sinor

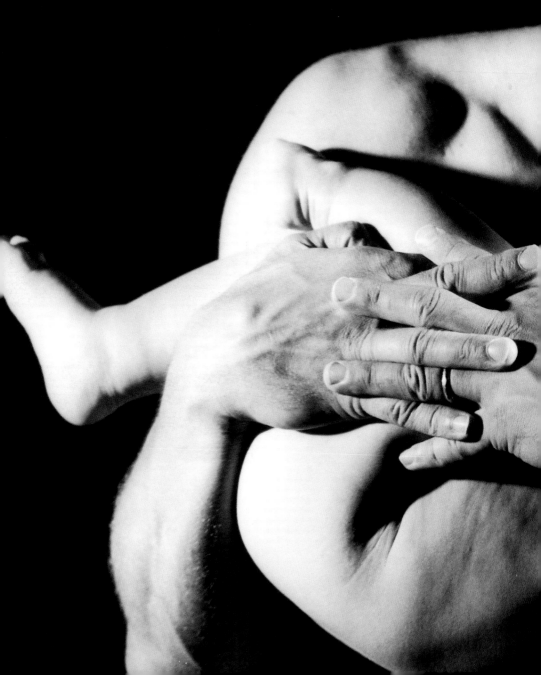

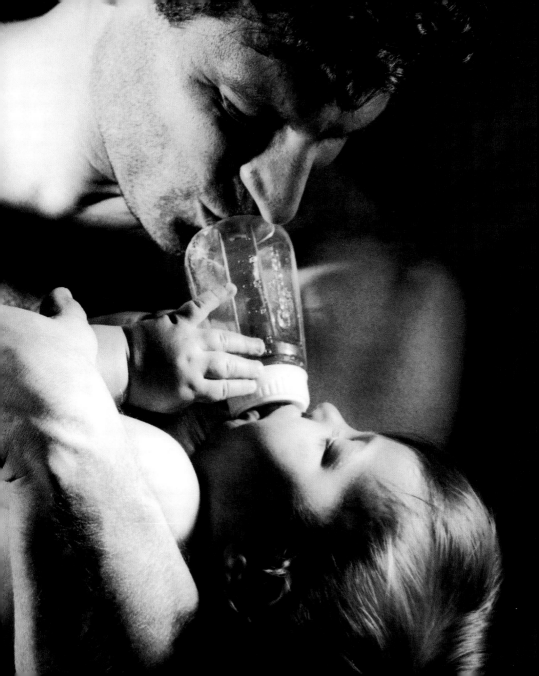

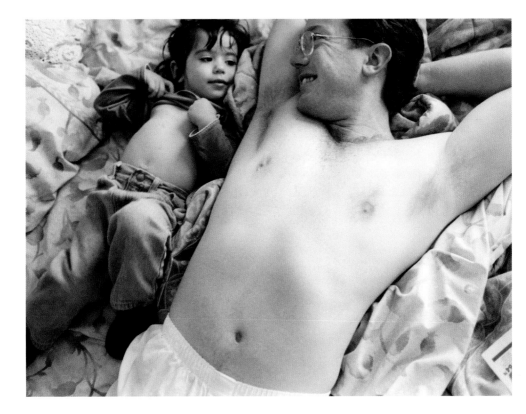

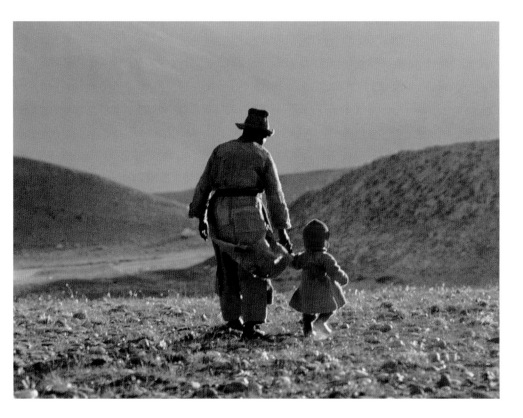

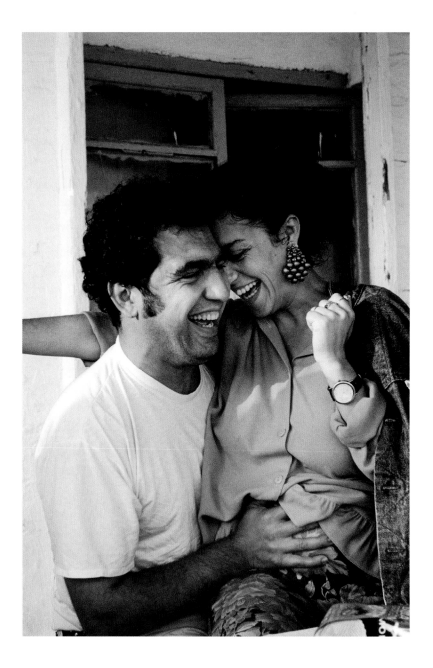

My father
believed in me.
What greater gift
could there be?

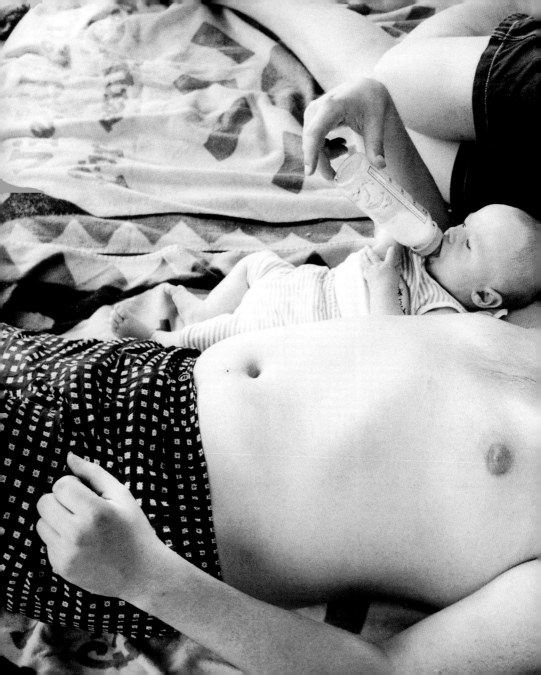

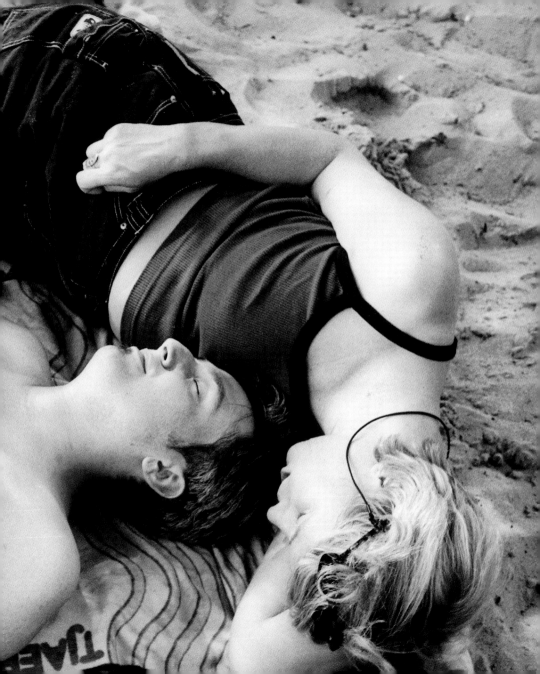

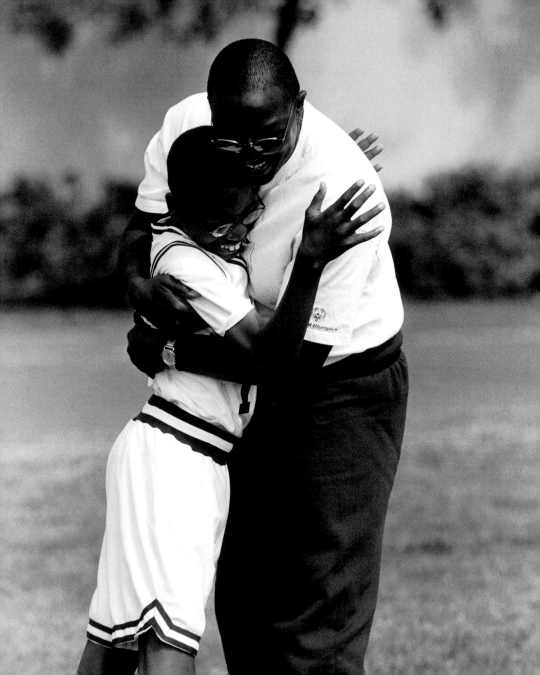

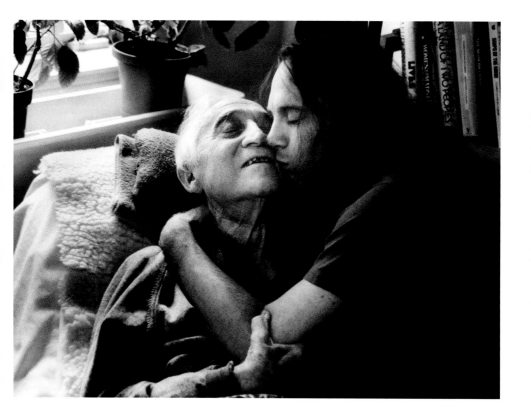

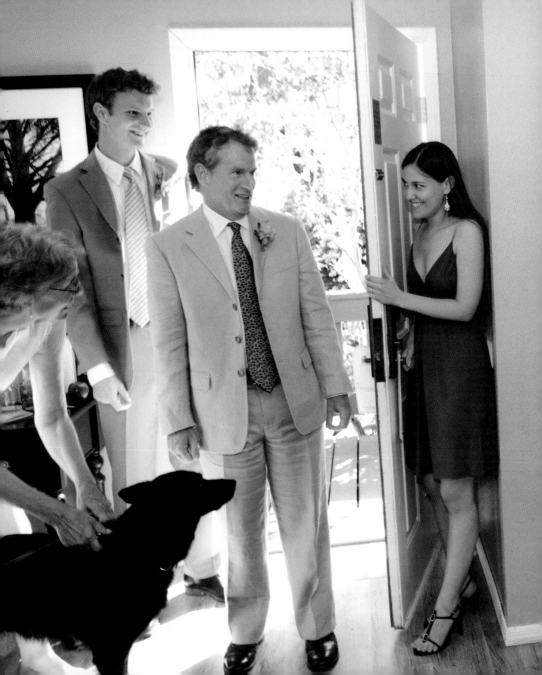

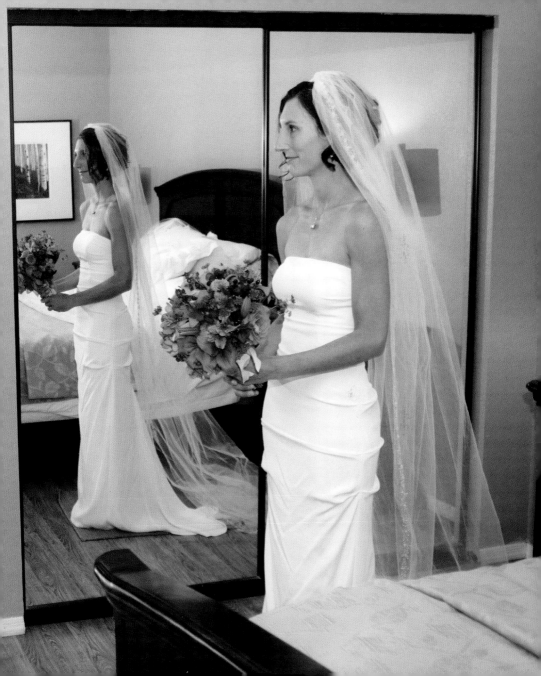

We never know the
love
of our parents
until we have
become
parents.

Henry Ward Beecher

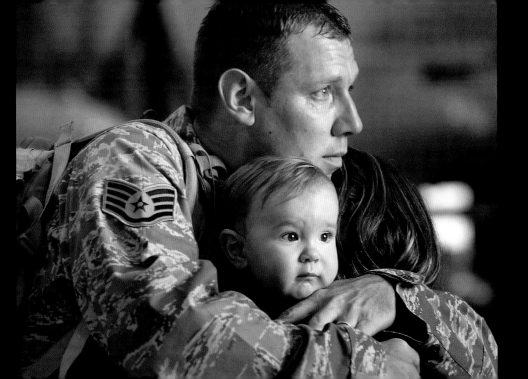

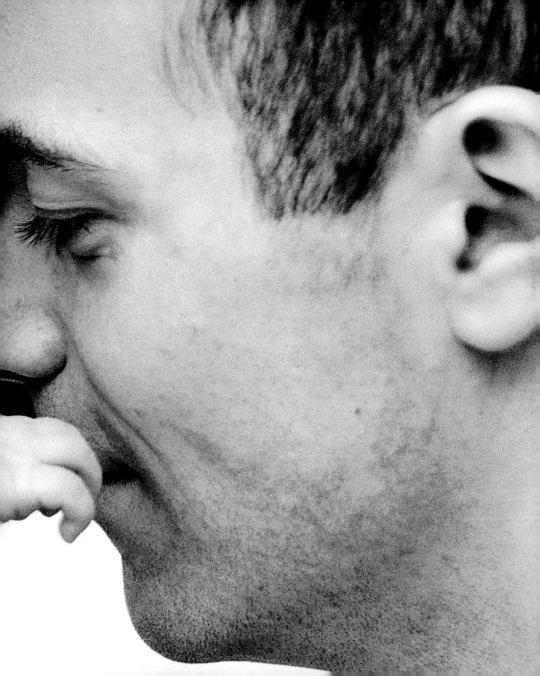

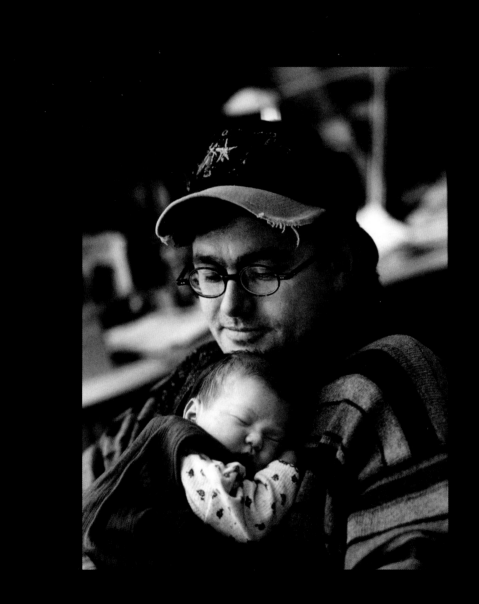

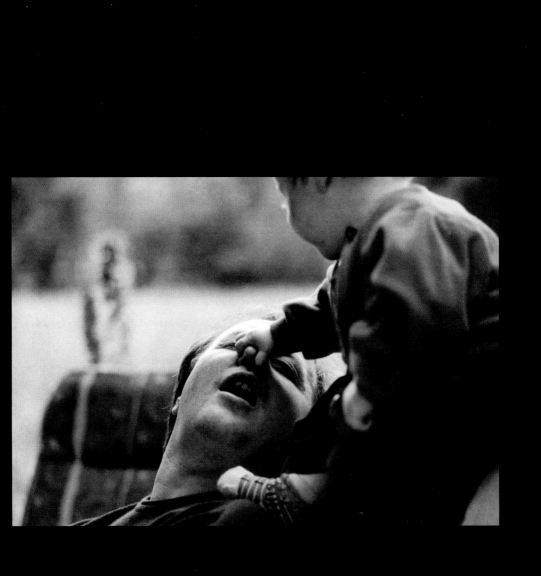

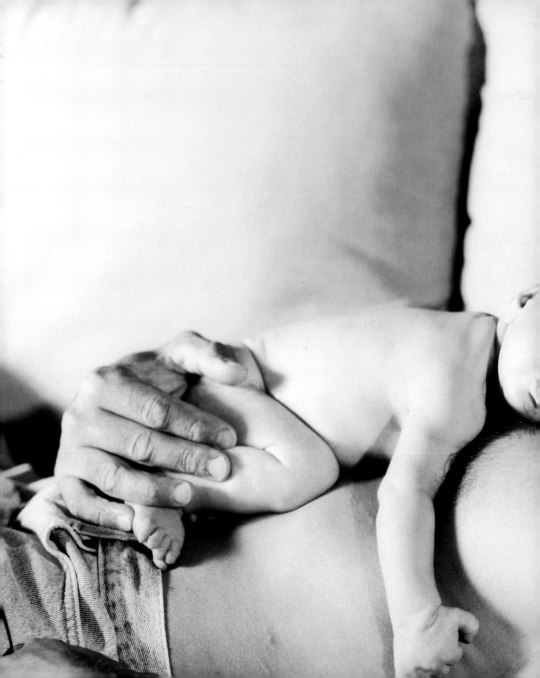

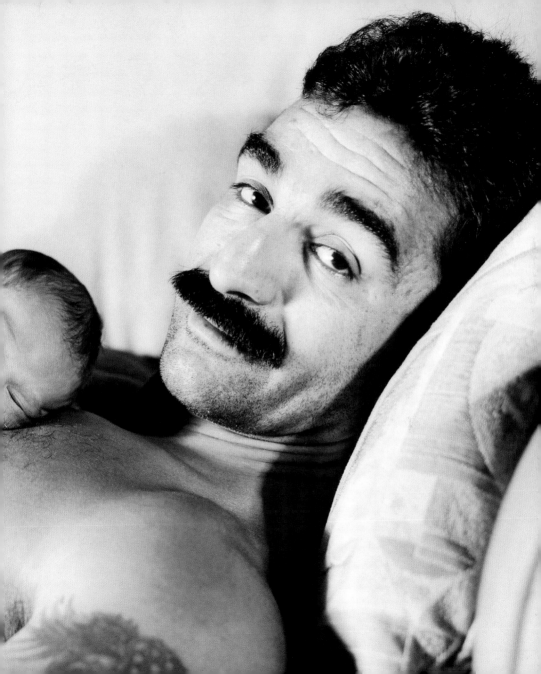

The thing to remember
about fathers is,
they're men.
A girl has to keep it in mind.
They are dragon-seekers,
bent on improbable rescues.
Scratch any father, you find someone
chock-full of qualms and romantic
terrors, *believing change is a threat*—like
your first shoes with heels on, like
your first bicycle it took months to get.

Phyllis McGinley

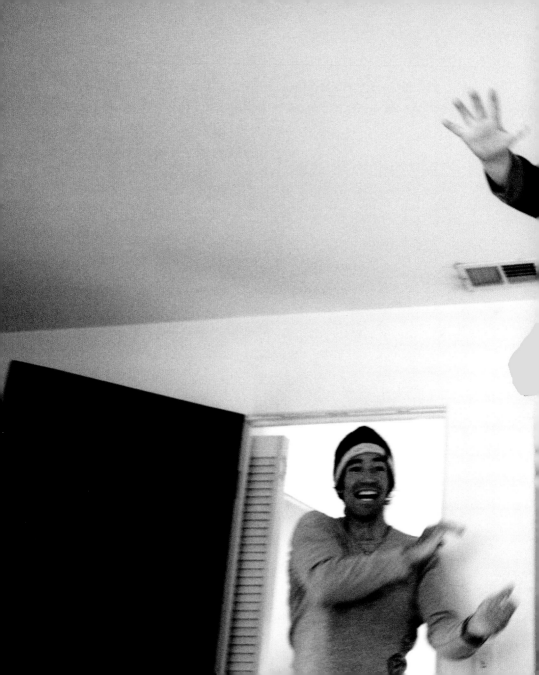

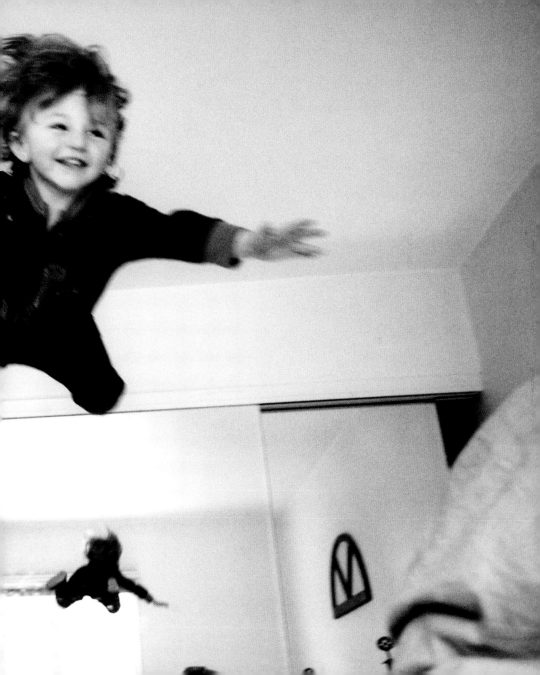

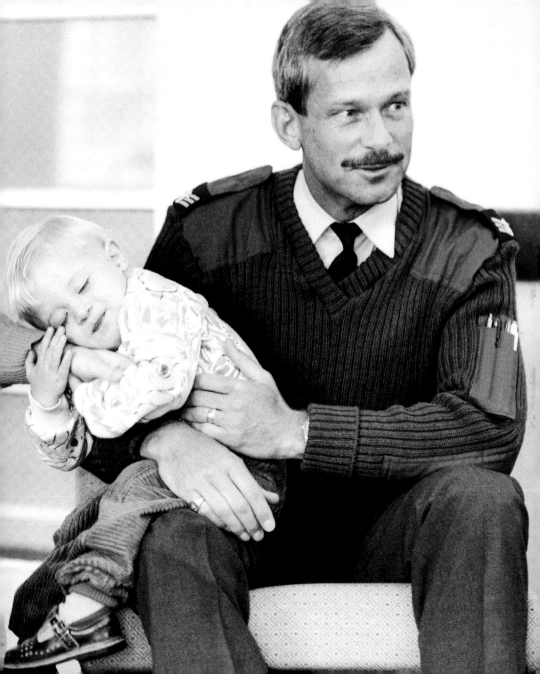

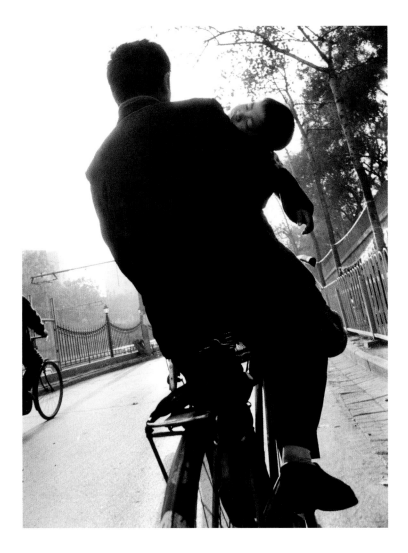

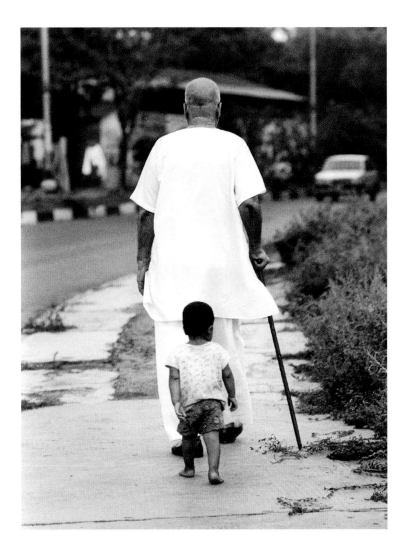

I love
my father
as the stars—

he's a bright, shining
example and a happy
twinkling in my

heart.

Adabella Radici

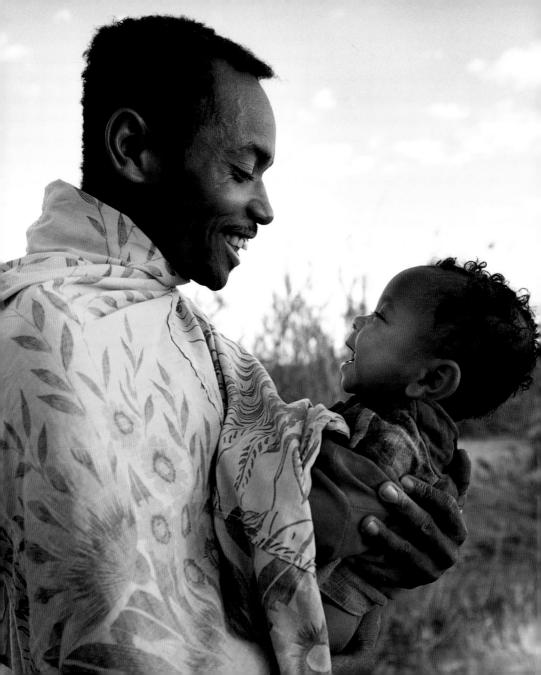

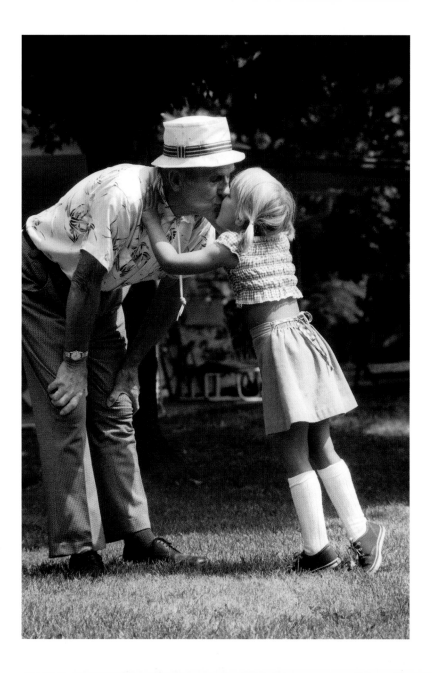

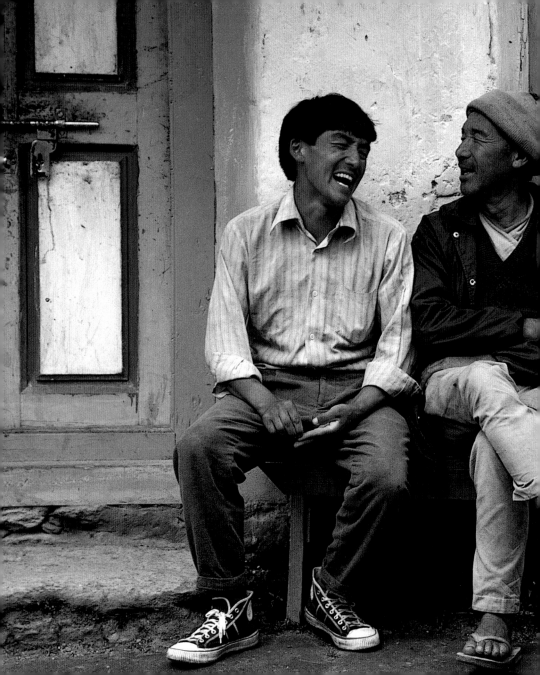

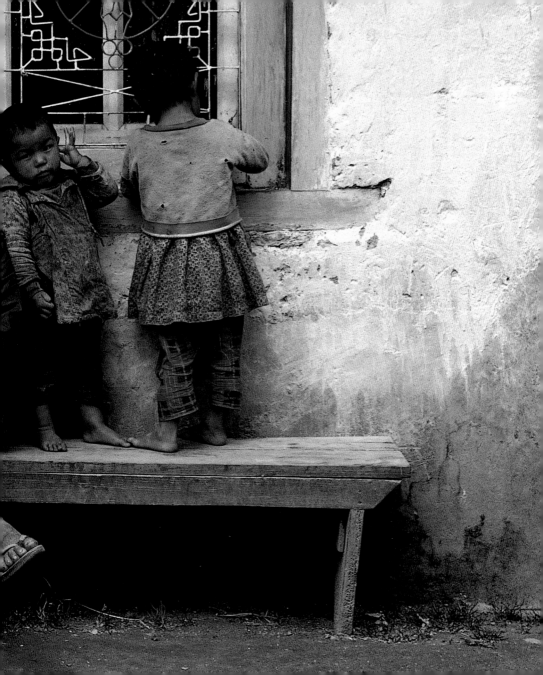

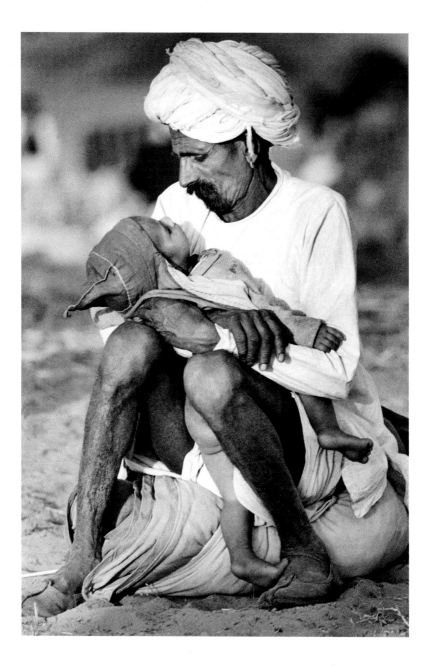

© Cheryl Jacobs Nicolai, USA
In Littleton, Colorado, USA, Sophia gazes up at her Grandpa Tracy.

© Graham Monro, Australia
Bridegroom Vince shares a pre-wedding moment with his father, Giuseppe, at the family home in Auburn, Sydney, Australia.

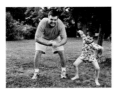

© Genevieve Fridley, USA
Will and his seven-year-old son, Andrew, flex their muscles at a summer party in Fayetteville, New York.

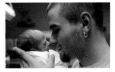

© John Marechal, Canada
In St Joseph's Hospital in Hamilton, Ontario, Canada, the photographer's son, Chris, holds his own son, Seth. Born prematurely, this is the first time Seth has been cuddled by his dad without being connected to a machine.

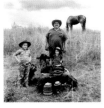

© Ray Peek, Australia
Another generation learns about mustering from the head of the family. 'Big' Morrie Dingle, a grazier in South Queensland, Australia, and his two grandsons take a break from the saddle to enjoy some food.

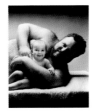

© Gordon Trice, USA
Father Heath holds his eight-month-old daughter, Bethany. This family portrait was photographed in Abilene, Texas, USA.

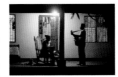

© Moshe Shai, Israel
A family spends a hot evening on their porch in Bluefields, a small port town on the east coast of Nicaragua.

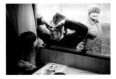

© Victoria Vaisvilaite Skirutiene, Lithuania
Two-year-old Mia is traveling with her family from Lithuania to Moscow in a camper van. Her father, Arunas, does his best to keep her entertained during a stop on the long journey.

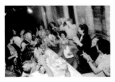

© Steven Baldwin, USA
Standing ovation—a man's rendition of a popular song is well received by his family at a street dinner in the village of Pisoniano, near Rome, in Italy.

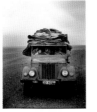

© Luca Trovato, USA
The Gobi Desert, Mongolia—stranded with all their belongings, a nomadic family are relaxed as they await help.

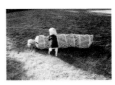

© Guus Rijven, Netherlands
Overcoming the generation gap in Brummen, the Netherlands. Eighty-one years separate a grandfather from his only grand-child, but that's no barrier to play. Two-year-old Jarón chooses the game.

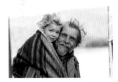

© Dave Marcheterre, Canada
Cheek to cheek—father and daughter hold each other close on a chilly morning in Gaspésie, Quebec, Canada.

© Kris Allan, UK
Father and son captured at the Goldstone soccer ground in Hove, UK.

© Sándor Horváth, Romania
The long road—an elderly man sees that his young relative comes to no harm as they make their way towards a small town in Transylvania, Romania.

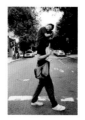

© Davi Russo, USA
Koa's father, Jima, piggybacks her down Second Avenue in New York, USA.

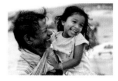

© Pietro Sutera, Germany
In Tamil Nadu, India, a little girl welcomes her father home from a long fishing trip.

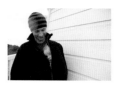

© Heidi Coppock Beard, New Zealand
At the top of a lighthouse on Awhitu Peninsula, New Zealand, Kirby shelters his daughter, Elizabeth, from the elements.

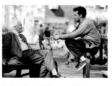

© Stephen Hathaway, UK
Charles and his grandson, Richard, are deep in conversation as they sit in Soho Square, London, UK.

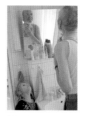

© Martin Langer, Germany
Four-year-old Emma mimics her grandfather, Alfred, as he shaves at his home in Göttingen, Germany.

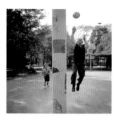

© Silvia Morara, Italy
A small boy and his grandfather play basketball in a park in Milan, Italy.

© Jeremy Rall, USA
A father lifts up his young son to give him a better view of a street festival in Santa Monica, California, USA.

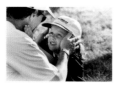

© Marc Rochette, Canada
A look of love and encouragement from father to daughter. Six-year-old Erica's soccer team from Bramalea, Canada, may not win very often, but her father is always on hand to support her efforts in the game.

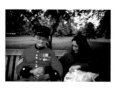

© Adriaan Oosthuizen, South Africa
A quiet moment as a Chelsea Pensioner, in distinctive red and black uniform, enjoys the company of his daughter in a park in London, UK. The Chelsea Pensioners are war veterans or retired military personnel.

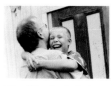

© Jane Wyles, New Zealand
Laughter is infectious for father and son, Drew and James, as they share an affectionate hug in Christchurch, New Zealand.

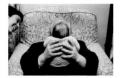

© David Williams, UK
Face to face—in Newcastle, UK, godfather David meets his one-month-old godson, Samuel, for the first time.

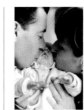

© SLim SFax
One-month-old Malik is the centre of attention for his loving parents, Cecile and Hafid, photographed at their home in Villeurbaine, France.

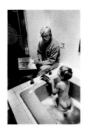

© Stacey P Morgan, USA
Bathtime story in Chester Springs, Pennsylvania, USA. Five-year-old Devin listens intently to his grand-father reading.

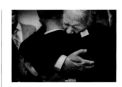

© Frank DiMeo, USA
Rodney embraces his newly married son, Ben, in upstate New York, USA.

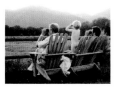

© Kathleen Hunter, USA
Fresh from his bath, his towel discarded, Thomas joins his father, Jack, and grandpa, Ross, in a spot of bird watching while on holiday in Jackson Hole, Wyoming, USA.

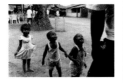

© Martin Rosenthal, Argentina
A father and his children in Juanchaco, Colombia.

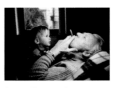

© Peter Thomann, Germany
When two-year-old Julian visits his grandparents' house in Emmendingen, Germany, he is fascinated by the smoke from grandfather Ernst's cigar.

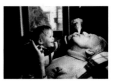

© Peter Thomann, Germany

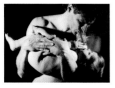

© Jim Witmer, USA
A photographer father takes a self-portrait with his one-year-old son, Adam, at home in Troy, Ohio, USA.

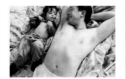

© Marcy Appelbaum, USA
In Jacksonville, Florida, USA, two-year-old Rachel is curious to see if her belly button matches her father's.

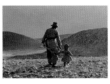

© Andrei Jewell, New Zealand
The beautiful mountain scenery of Zanskar in the Indian Himalayas is the setting for a twilight stroll. In a region which is snow-covered for most of the year, Norbu and his young granddaughter make the most of the warm sunshine.

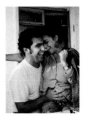

© Pepe Franco, USA
Father-to-be Angel can't help laughing as he tells a joke to his unborn baby. This image of Angel and his partner, Isabel, was captured during a family party in Aguilas, Spain.

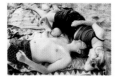

© Lorenz Kienzle, Germany
A family lies in relaxed contentment on the shore of the River Elbe in Germany. While his parents sleep off their picnic lunch, three-month-old Jan enjoys a drink of his own.

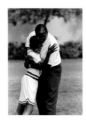

© John McNamara, USA
The Special Olympics in Union City, California—father Daryl gives his son, JR, a hug full of love and pride after the young competitor finishes his event.

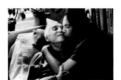

© Heather Pillar, Taiwan
Rob Schwartz with his father, Morrie. Mitch Albom, a writer and former student of Morrie, noticed Morrie on a television show and renewed contact with his old professor. The outcome was Albom's moving bestseller *Tuesdays with Morrie*, based on time spent with Morrie on the last fourteen Tuesdays of his life.

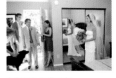

© Pamela Duffy, USA
Hana the bride is captured with her family: father, mother, brother, best friend, and Akasha the dog who acts as ring bearer.

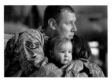

© Jane Thérèse, USA
At the air force base in Willow Grove, Pennsylvania, USA, airman Jason Koder embraces his new wife and young son before he heads off for his third deployment to Afghanistan.

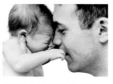

© Shannon Eckstein, Canada
Rubbing noses in Vancouver, Canada—new father Davy finds the perfect way to bond with his baby daughter, Ciara, only nine days old.

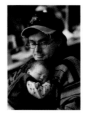

© Michael Decher, Germany
'Klara and me'—this self-portrait captures a father's face full of tenderness and love as he holds his one-week-old daughter.

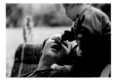

© Reinhard David, Austria
Young Jakob makes a memorable first impression when he is introduced to his Uncle Christian at a family party near Vienna, Austria.

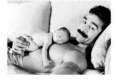

© Henry Hill, USA
Eight-day-old Cyrus is content and secure as he lies sleepily on his father, Joe. The young baby had only just left hospital and this image was taken on his first day at home in Colorado Springs, Colorado, USA.

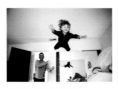

© Jonas Jungblut, USA
In Santa Barbara, California, USA, one-year-old Keean and his father, Marcus, play a game that involves Keean being tossed on to a bed piled with blankets.

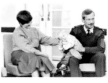

© Edmond Terakopian, UK
A family is reunited. British Royal Air Force sergeant John has just returned from the Gulf War to his wife, Sharon, and their two-year-old son, Phillip. Their reunion was captured during a press conference in Stanmore, Middlesex, UK.

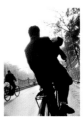

© Tong Wang, China
A father holds his sleeping child as he cycles through Zhengzhou, China.

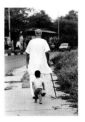

© Rajib De, India
Three-year-old Tito follows in the footsteps of an eighty-two-year-old professor on an afternoon stroll through Calcutta, India.

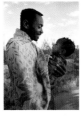

© Louise Gubb, South Africa
The simple love of a family bonds a father and son beside the Fiherenana River in Madagascar. The Malagasy people come to this area to mine for sapphires.

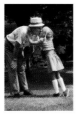

© Mark Engledow, USA
The photographer's daughter—six-year-old Kitty—stretches on tip-toe to give her grandfather, Bert, a kiss in Bloomington, Indiana, USA.

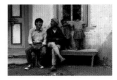

© Joan Sullivan, Canada
The babysitter—in the foothills of the Himalayas, a Nepalese grand-father looks after his two grand-children while he catches up on news brought from Kathmandu by a young porter.

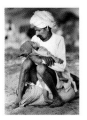

© Madan Mahatta, India
While his parents visit a camel fair in the desert of Rajasthan, India, a young child enjoys the tender love and care of his grand-father.

First published in the United States in 2010 by PQ Blackwell in association with Chronicle Books LLC.

Concept and design copyright © 2010 PQ Blackwell Limited
Published under licence from M.I.L.K. Licensing Limited
Copyright © 2010 M.I.L.K. Licensing Limited. All rights reserved
The M.I.L.K. logo is copyright © M.I.L.K. Licensing Limited

Edited by Geoff Blackwell
Book design by Cameron Gibb

Library of Congress Cataloging-in-Publication Data available.

ISBN: 978-0-473-15716-6

Manufactured in China

Produced and originated by PQ Blackwell Limited, 116 Symonds Street, Auckland, New Zealand
www.pqblackwell.com

10 9 8 7 6 5 4 3 2 1

Chronicle Books LLC
680 Second Street, San Francisco, California 94107
www.chroniclebooks.com

www.milkphotos.com

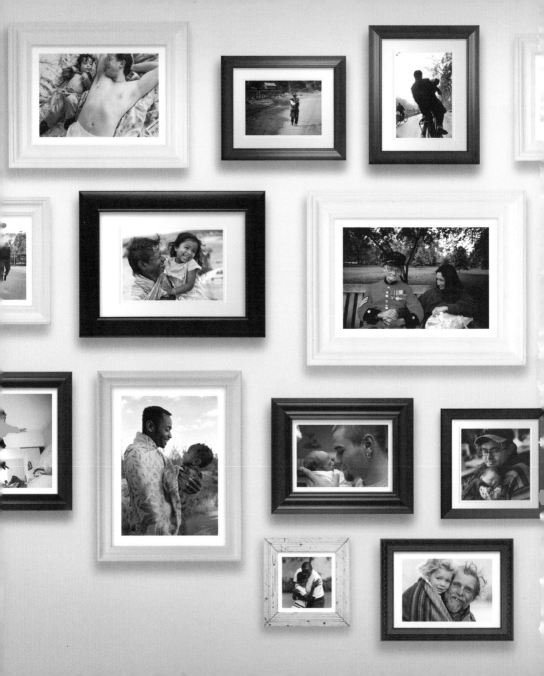